Color Your Own
ITALIAN RENAISSANCE
MASTERPIECES

RENDERED BY MARTY NOBLE

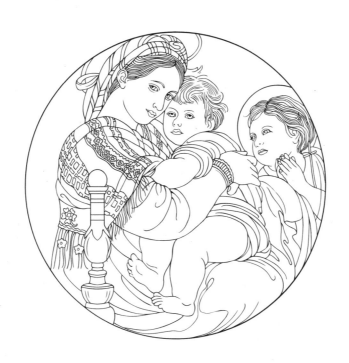

DOVER PUBLICATIONS, INC.
Mineola, New York

Note

The Italian Renaissance was one of the most prolific eras in art history. The Renaissance, which was a "rebirth" of artistic expression, officially began at the end of the fourteenth century and peaked in the late fifteenth century. This art movement, accompanied by tremendous change in cultural attitudes, had artists reassessing their entire perceptions of nature and anatomy. Numerous innovations in both art and science culminated in an emphasis on realistic proportions, perspective, and subject matter. Both religious and secular paintings benefited from these developments.

During this rich period of cultural achievement, a new distinction was established between the artisan, or craftsperson, and the individualized, unique talents of the artist. Leonardo da Vinci, Michelangelo, and Raphael are listed among the great masters of the Italian Renaissance, and their enduring influence still sets a high standard for artists and painters of today.

All thirty of the paintings and frescoes in this book are shown in full color on the inside front and back covers. By using this color scheme as a guide, you can create your own artistic interpretation of an Italian Renaissance masterpiece or, if you wish, you can use different colors to see the effects of mood and tone.

Bibliographical Note

Color Your Own Italian Renaissance Masterpieces is a new work, first published by Dover Publications, Inc., in 2008.

DOVER *Pictorial Archive* SERIES

This book belongs to the Dover Pictorial Archive Series. You may use the designs and illustrations for graphics and crafts applications, free and without special permission, provided that you include no more than four in the same publication or project. (For permission for additional use, please write to Permissions Department, Dover Publications, Inc., 31 East 2nd Street, Mineola, N.Y. 11501.)

However, republication or reproduction of any illustration by any other graphic service, whether it be in a book or in any other design resource, is strictly prohibited.

International Standard Book Number

ISBN-13: 978-0-486-46532-6
ISBN-10: 0-486-46532-2

Manufactured in the United States of America
Dover Publications, Inc., 31 East 2nd Street, Mineola, N.Y. 11501

1. **Fra Angelico** (ca. 1400–1455). *The Annunciation.*

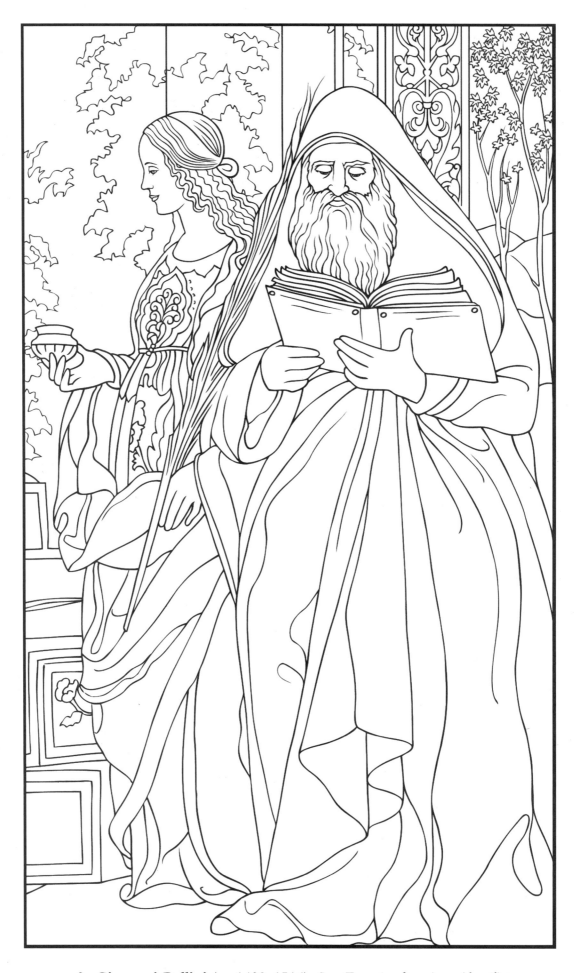

2. **Giovanni Bellini** (ca. 1430–1516). *San Zaccaria*, altarpiece (detail).

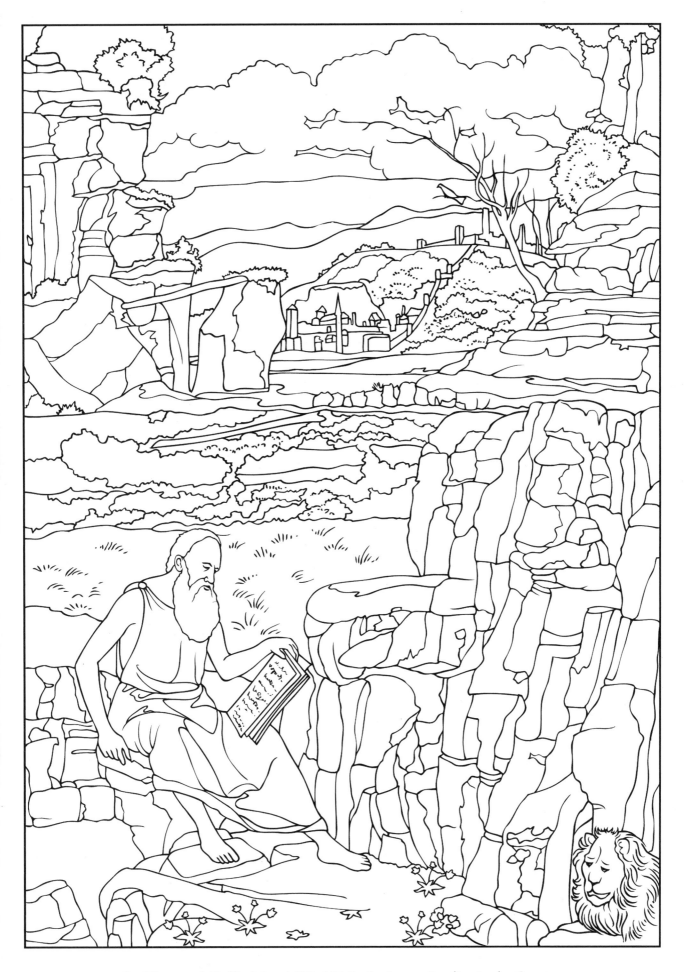

3. **Giovanni Bellini** (ca. 1430–1516). *St. Jerome Reading in the Country.*

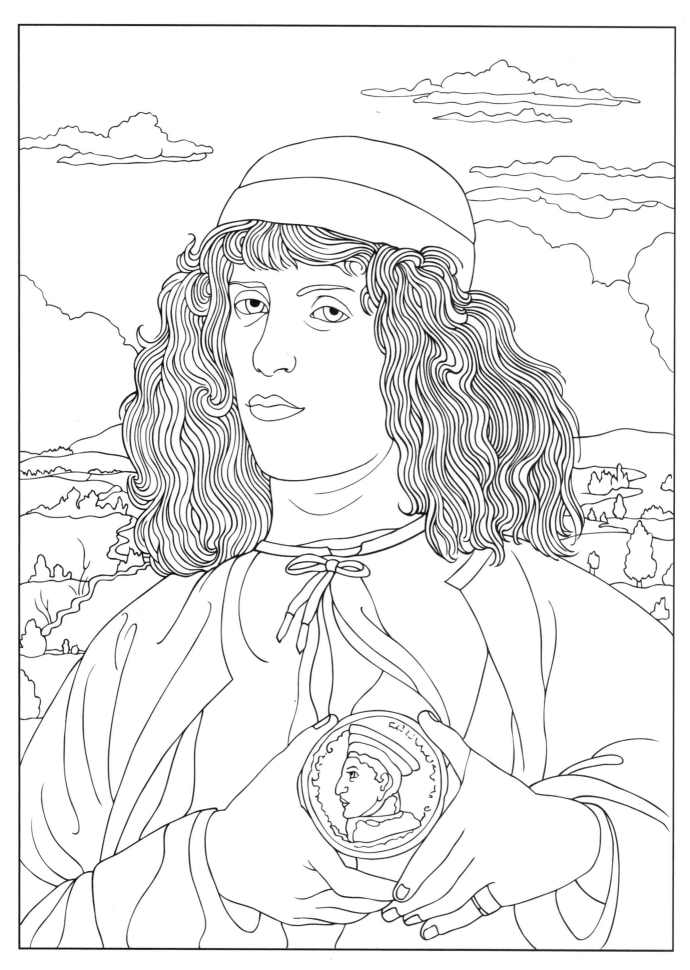

4. **Sandro Botticelli** (ca. 1445–1510). *Portrait of a Man with a Medal of Cosimo the Elder.*

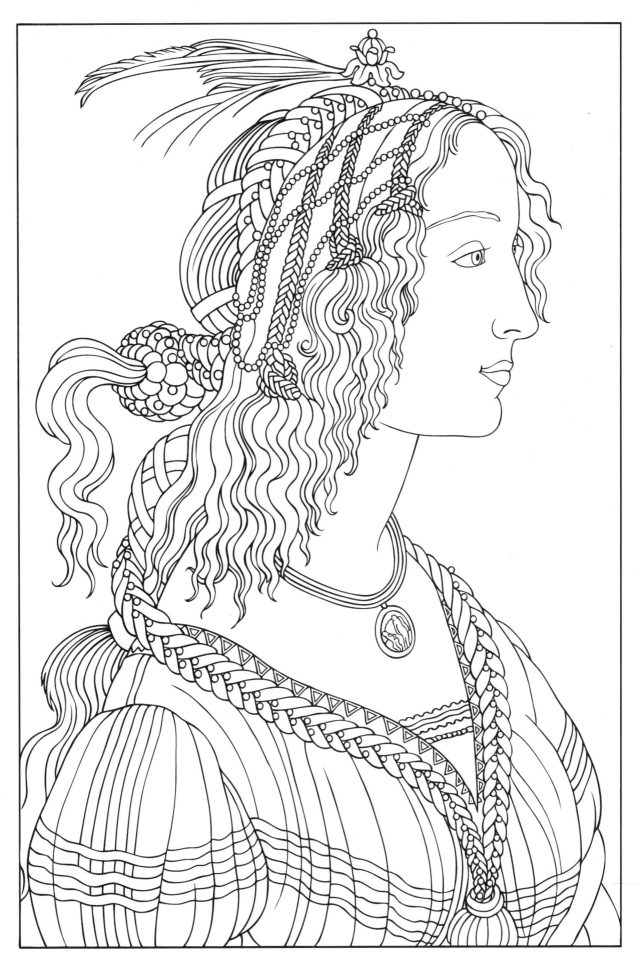

5. **Sandro Botticelli** (ca. 1445–1510). *Young Woman in a Mythological Guise.*

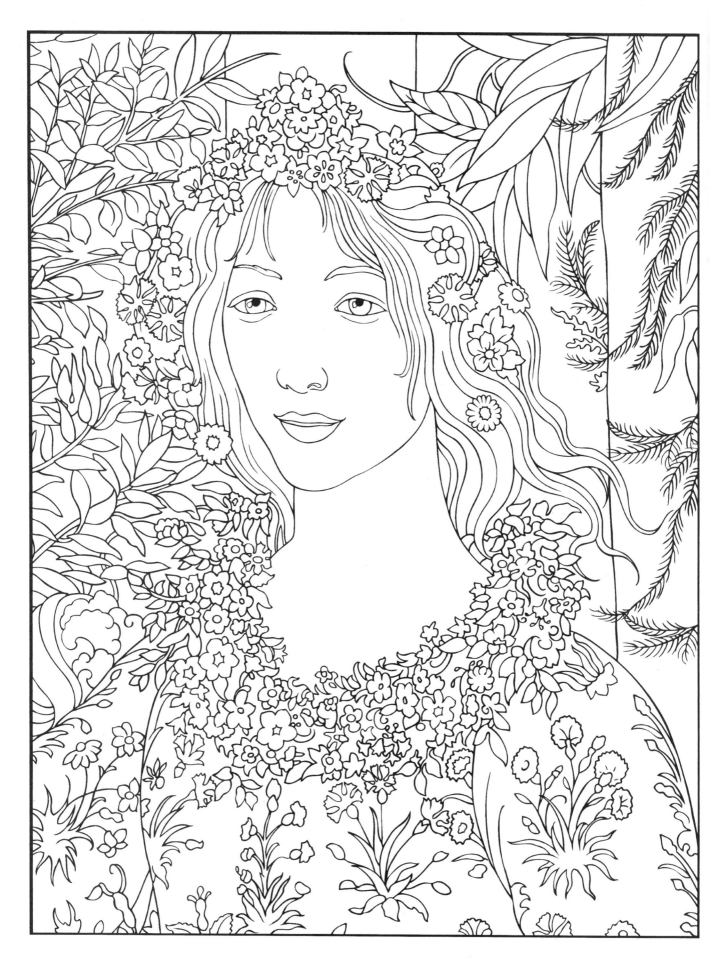

6. **Sandro Botticelli** (ca. 1445–1510). *Primavera* (detail).

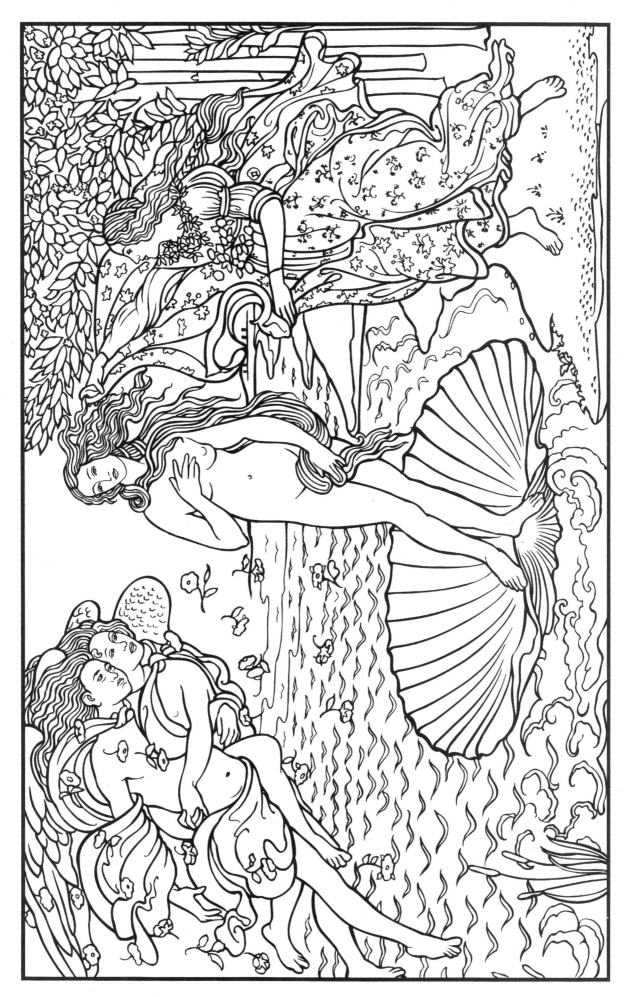

7. **Sandro Botticelli** (ca. 1445–1510). *The Birth of Venus.*

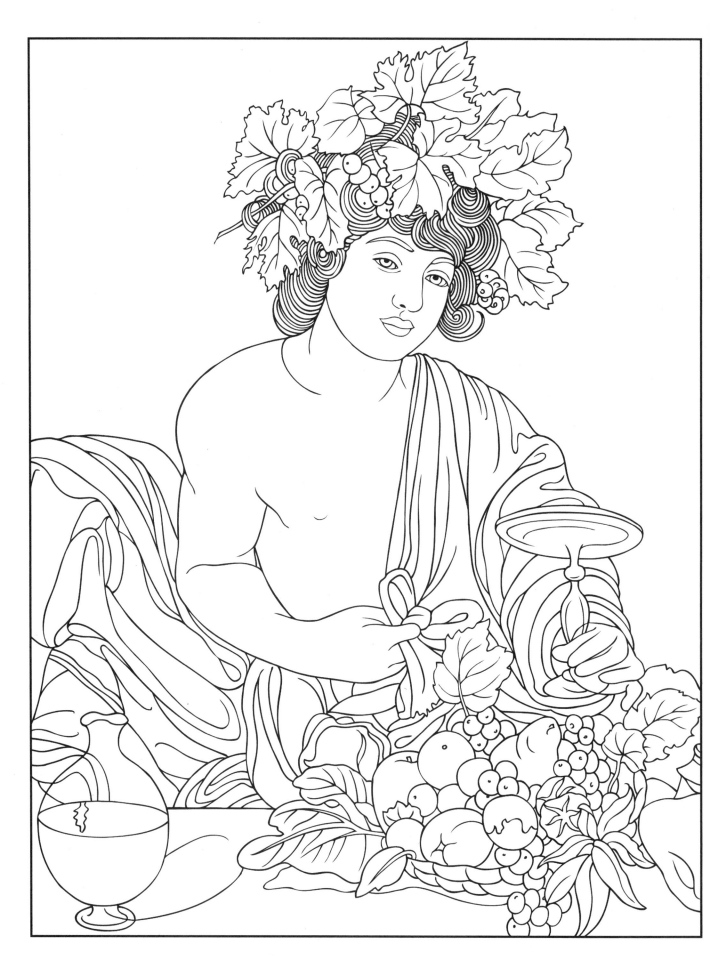

8. **Caravaggio** (1573–1610). *Bacchus.*

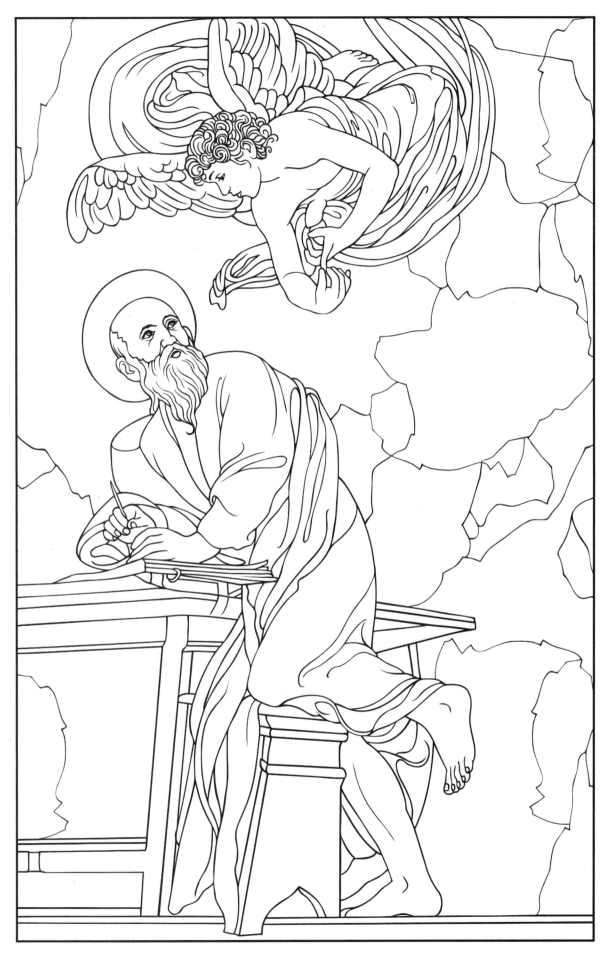

9. **Caravaggio** (1573–1610). *St. Mathew: The Angel.*

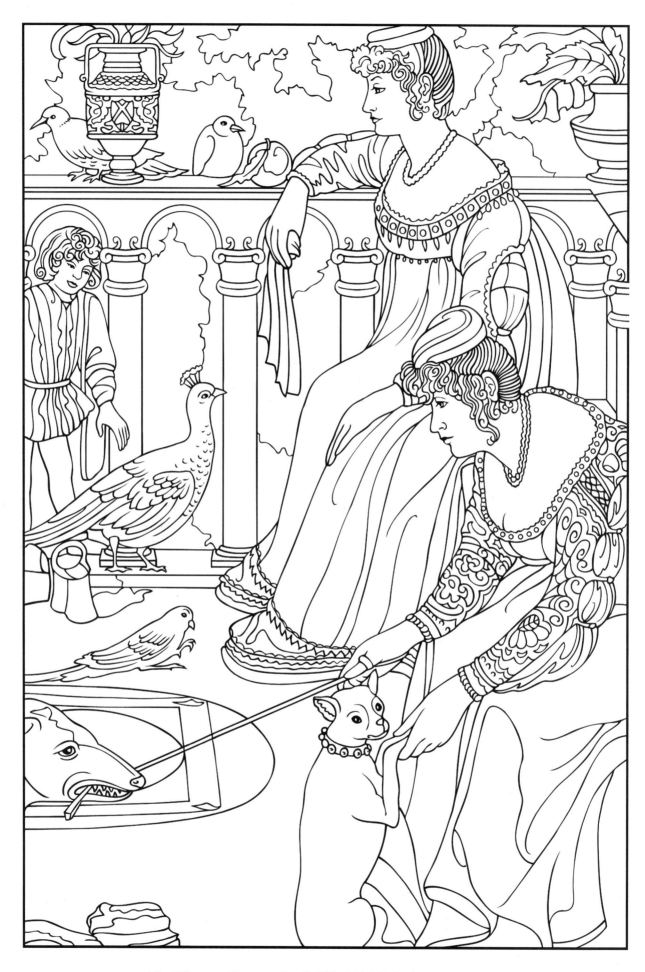

10. **Vittore Carpaccio** (1455–1526/27). *Two Courtesans.*

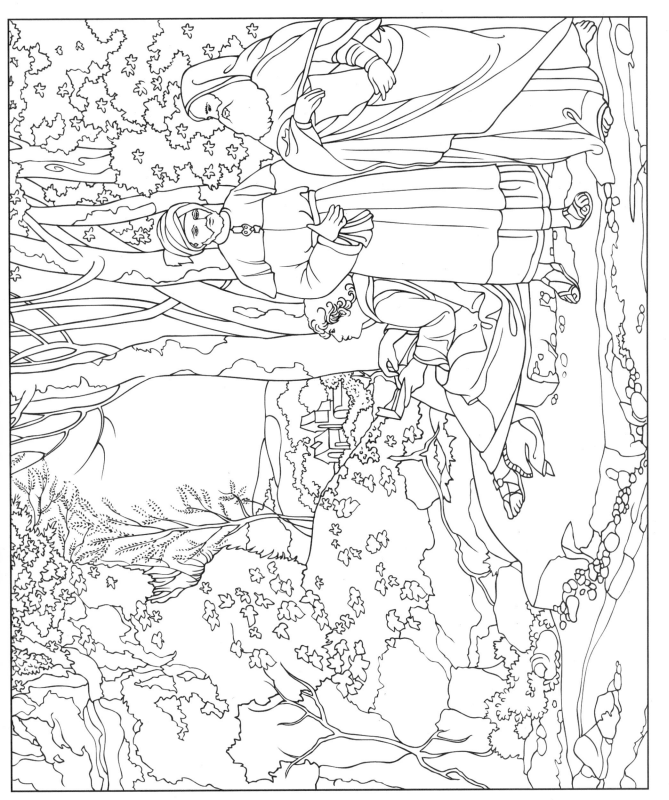

11. **Giorgione** (1477–1510). *The Three Philosophers.*

12. **Giorgione** (1477–1510). *The Adoration of the Shepherds.*

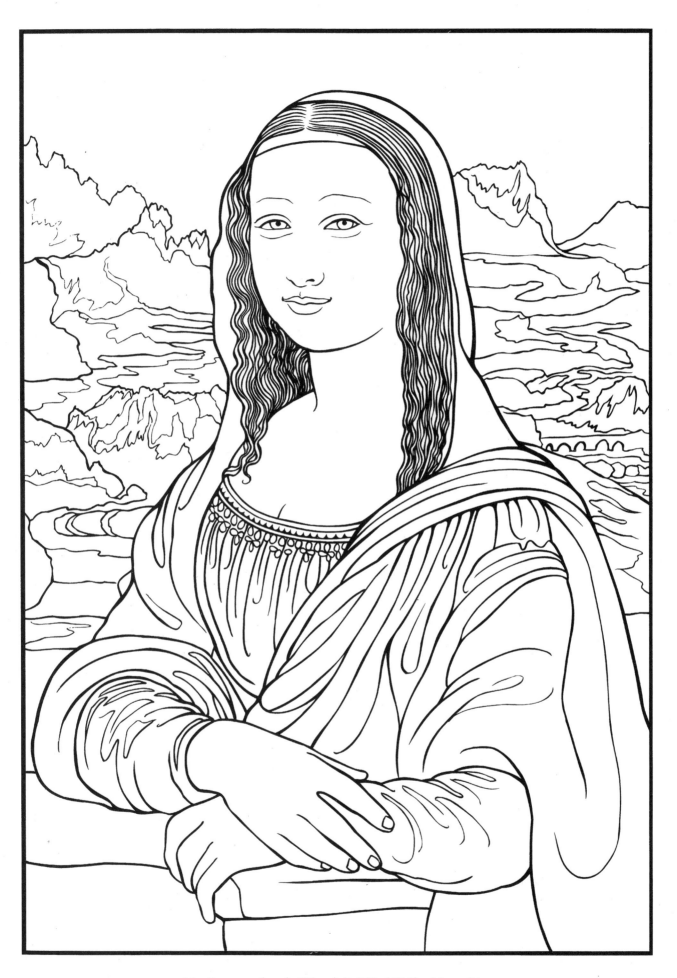

13. **Leonardo da Vinci** (1452–1519). *Mona Lisa.*

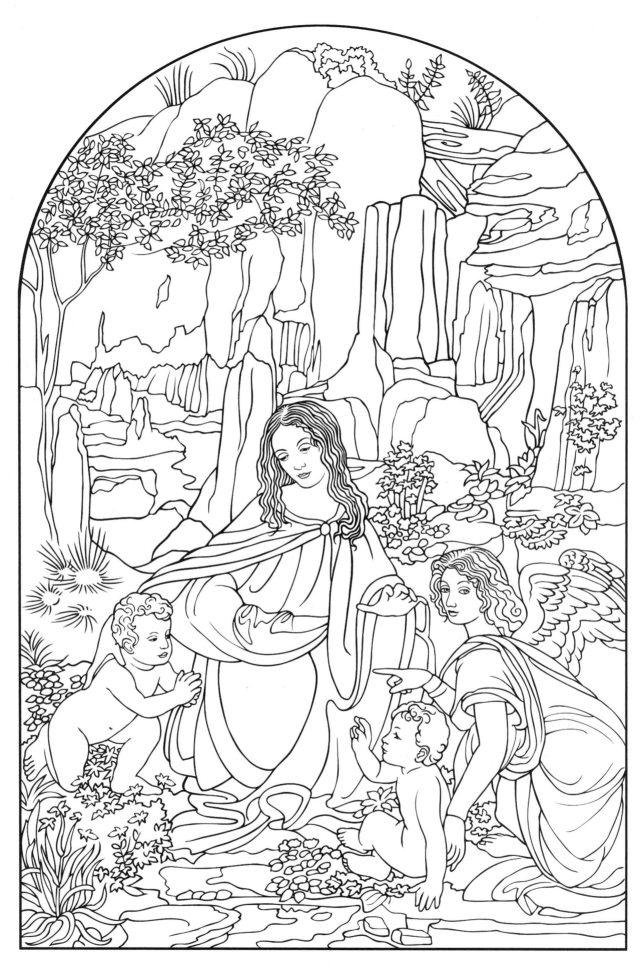

14. **Leonardo da Vinci** (1452–1519). *Virgin of the Rock*.

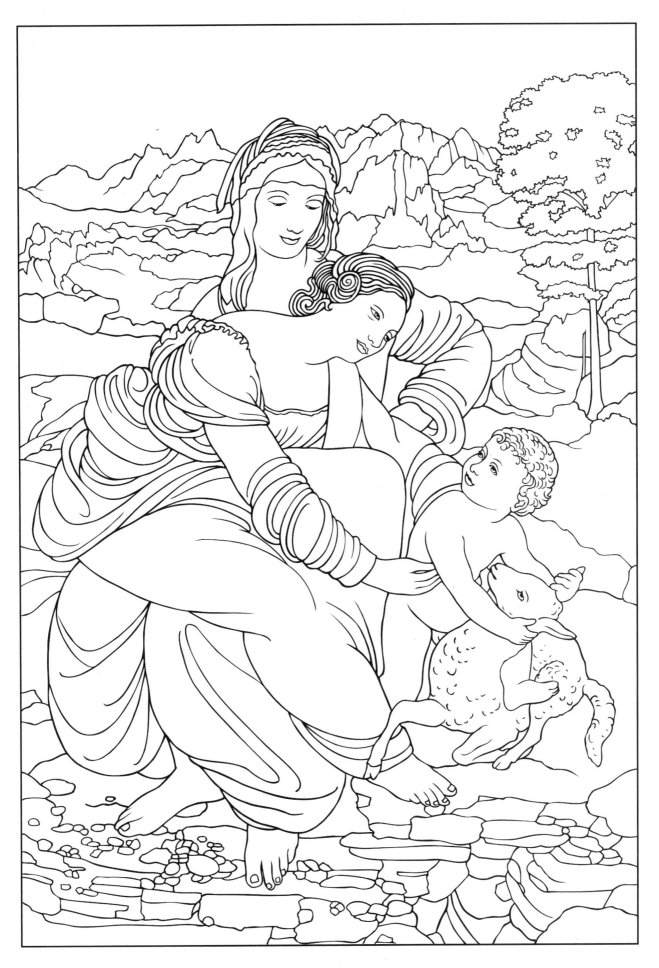

15. **Leonardo da Vinci** (1452–1519). *The Virgin and Child with St. Anne.*

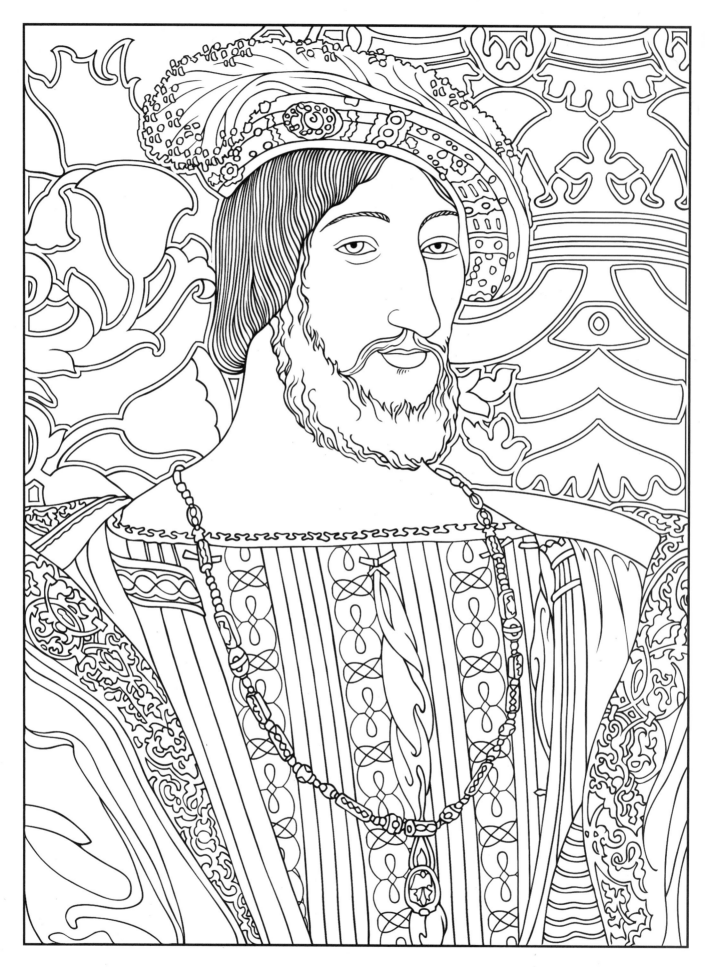

16. **Leonardo da Vinci** (1452–1519). *Francois I.*

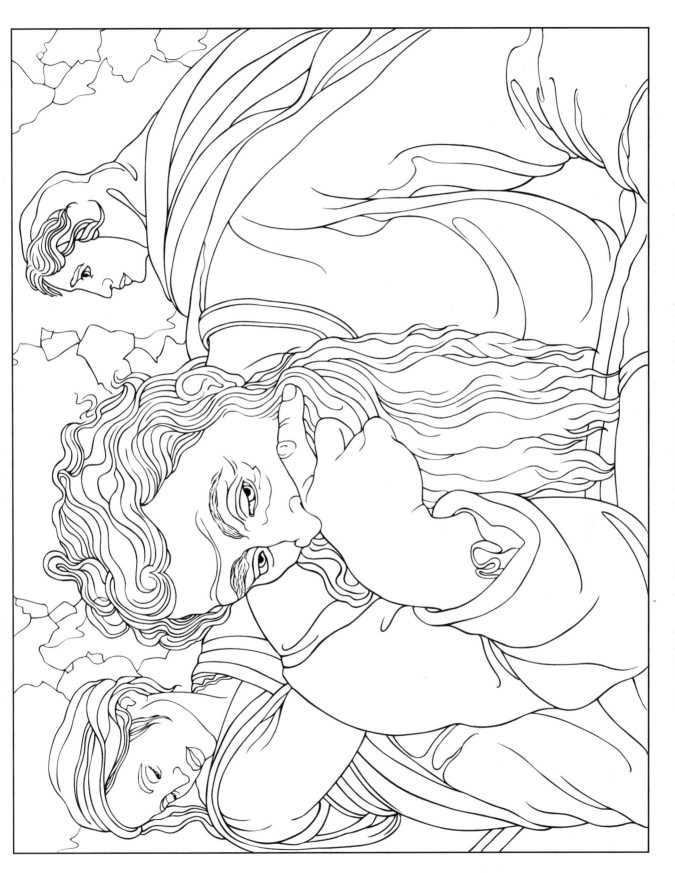

17. **Michelangelo Buonarroti** (1475–1564). *Jeremiah* (detail from Sistine Chapel).

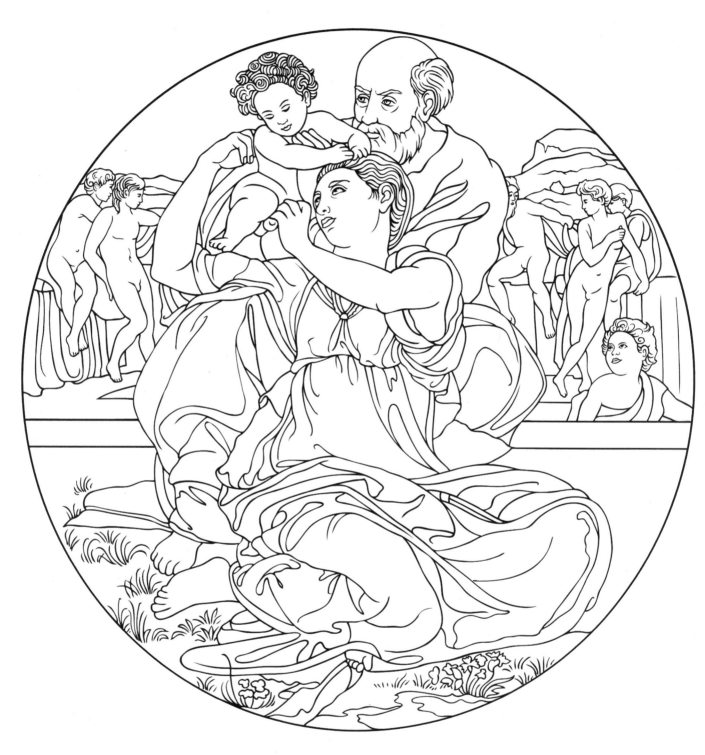

18. **Michelangelo Buonarroti** (1475–1564). *The Doni Tondo.*

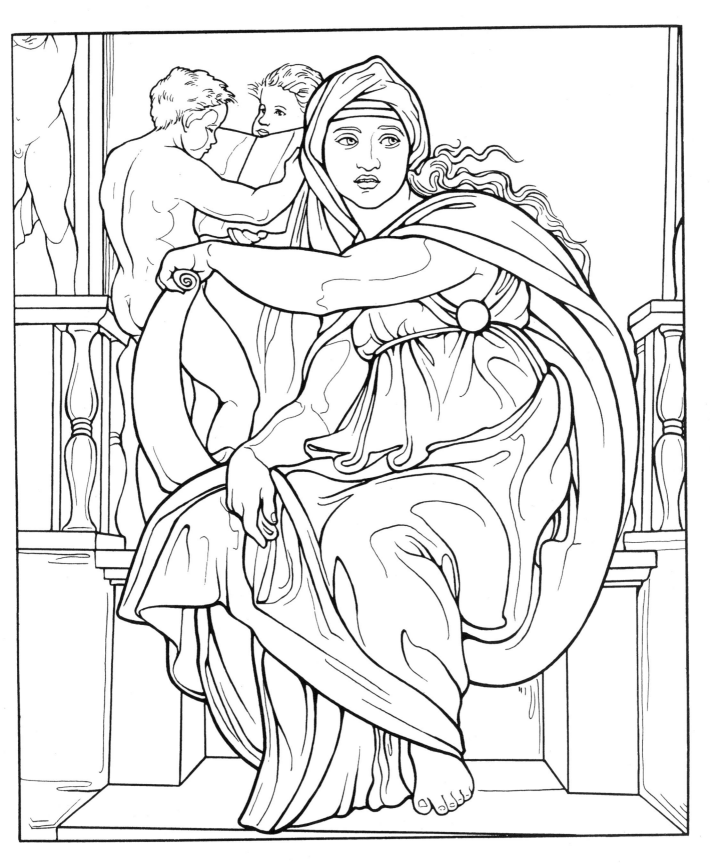

19. **Michelangelo Buonarroti** (1475–1564). *The Delphic Sibyl* (from Sistine Chapel).

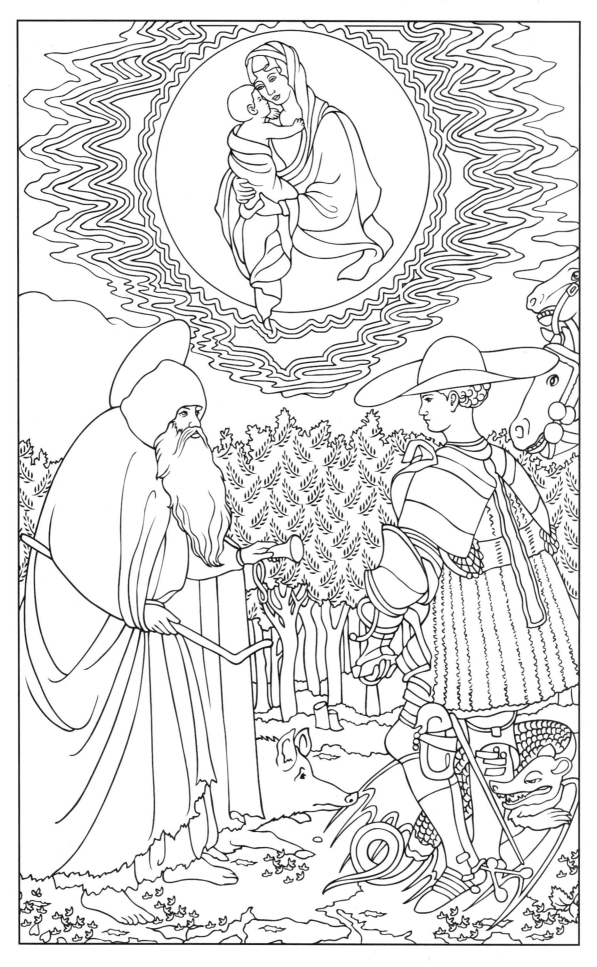

20. **Pisanello** (1395–1455). *The Virgin and Child with Saints George and Anthony Abbott.*

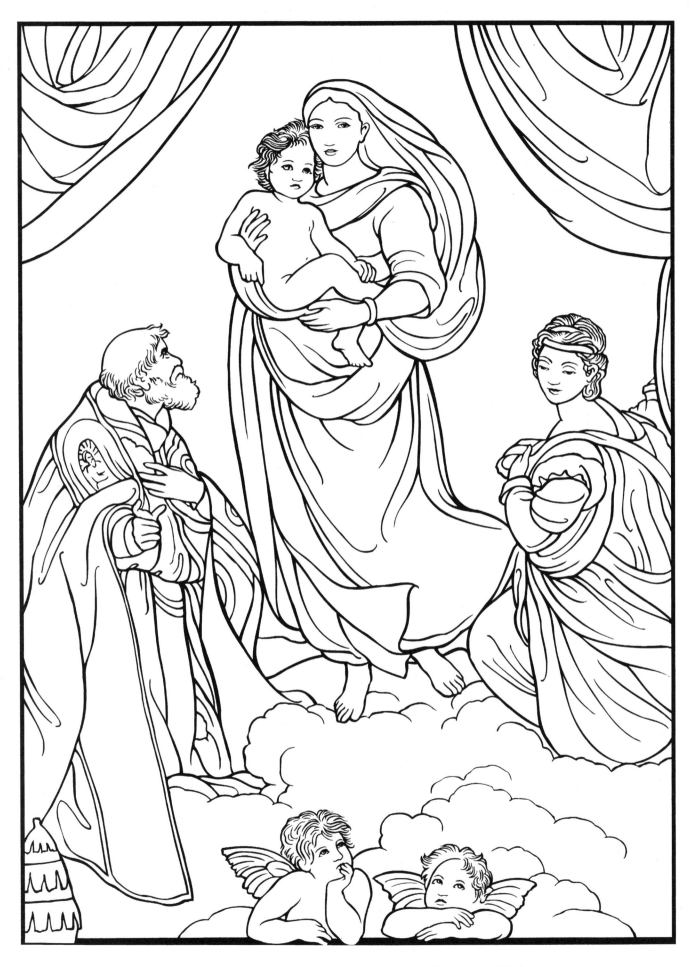

21. **Raphael** (Raffaello Sanzio; 1483–1520). *The Sistine Madonna.*

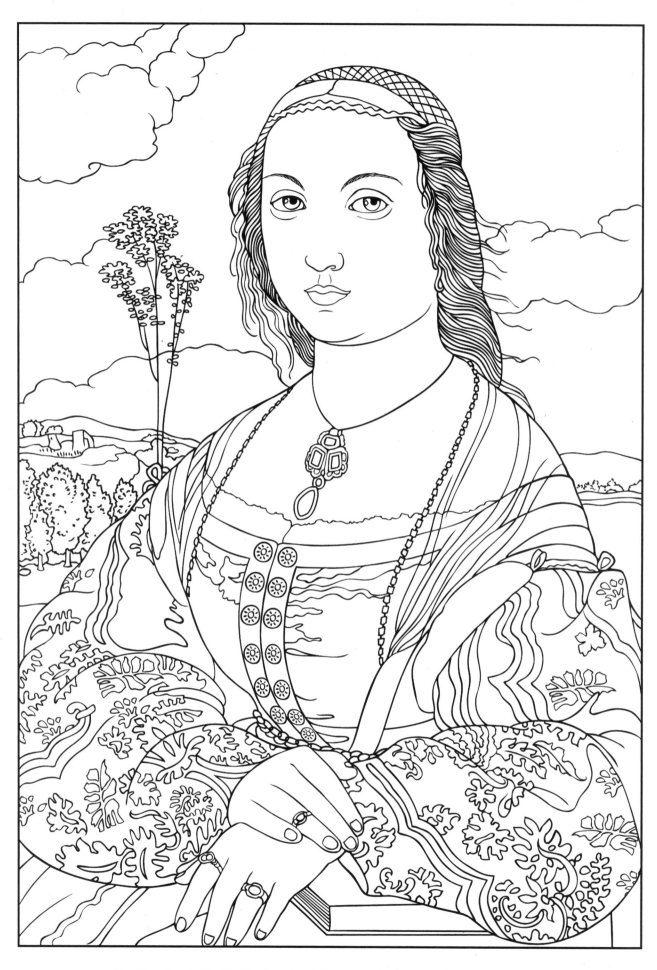

22. **Raphael** (Raffaello Sanzio; 1483–1520). *Portrait of Magdalena Dori.*

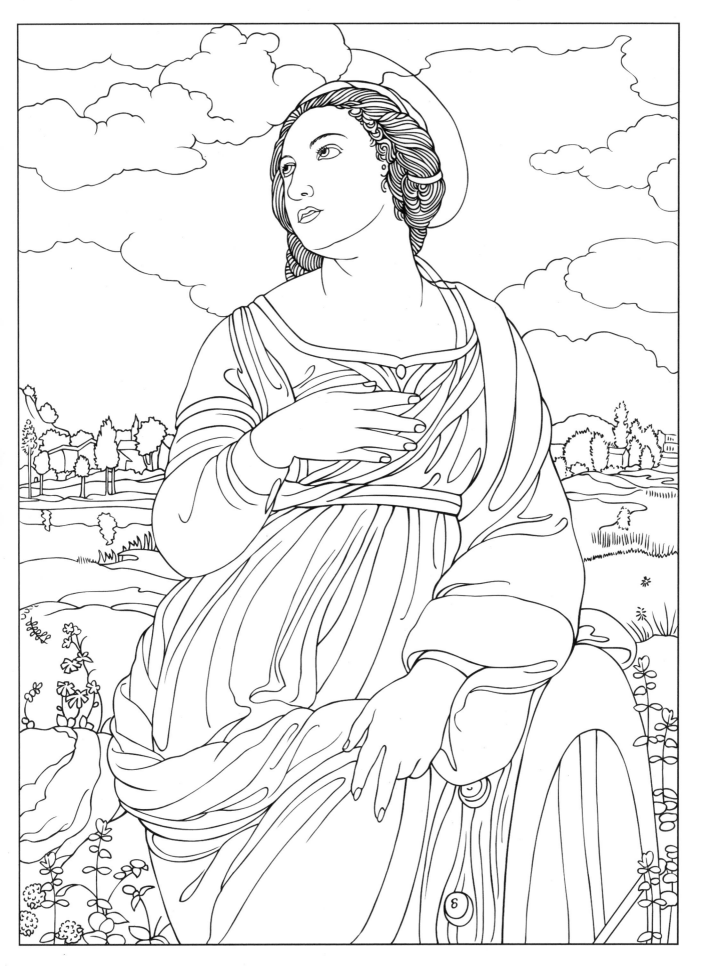

23. **Raphael** (Raffaello Sanzio; 1483–1520). *St. Catherine of Alexandria.*

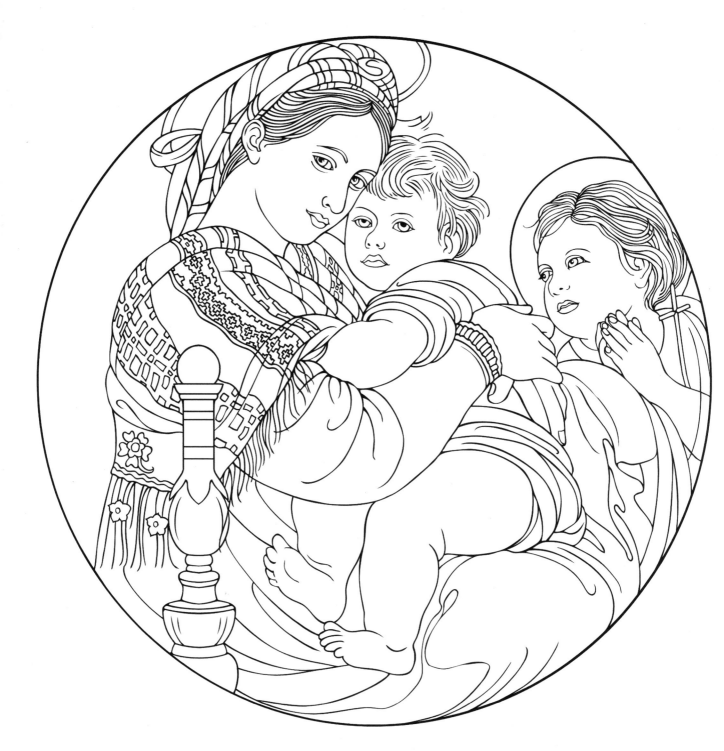

24. **Raphael** (Raffaello Sanzio; 1483–1520). *Madonna Della Sedia.*

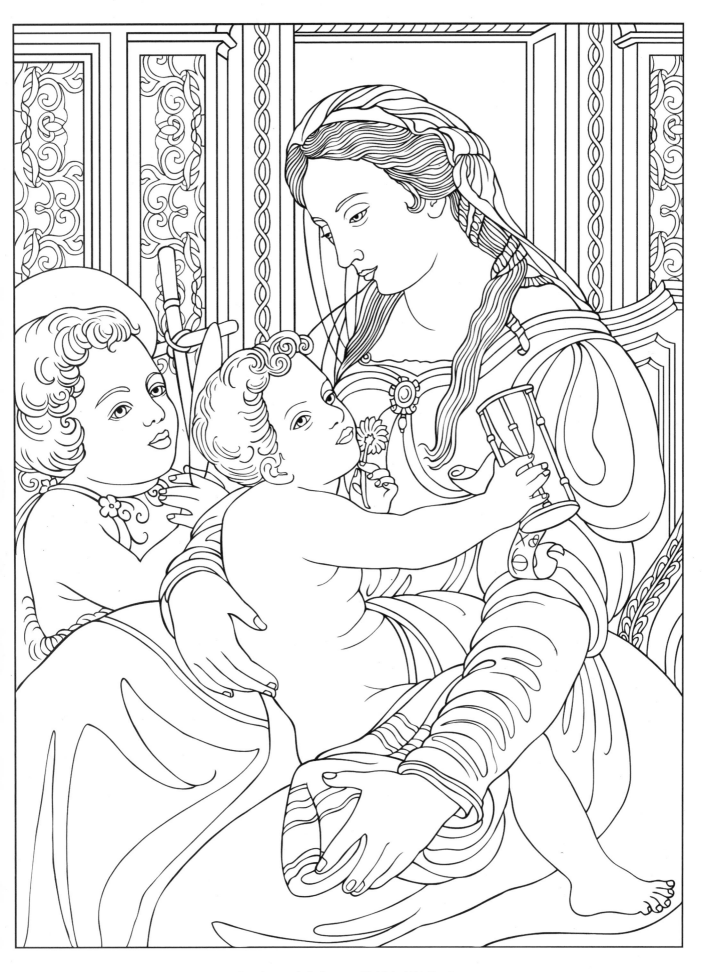

25. **Andrea del Sarto** (1486–1531). *Seguace.*

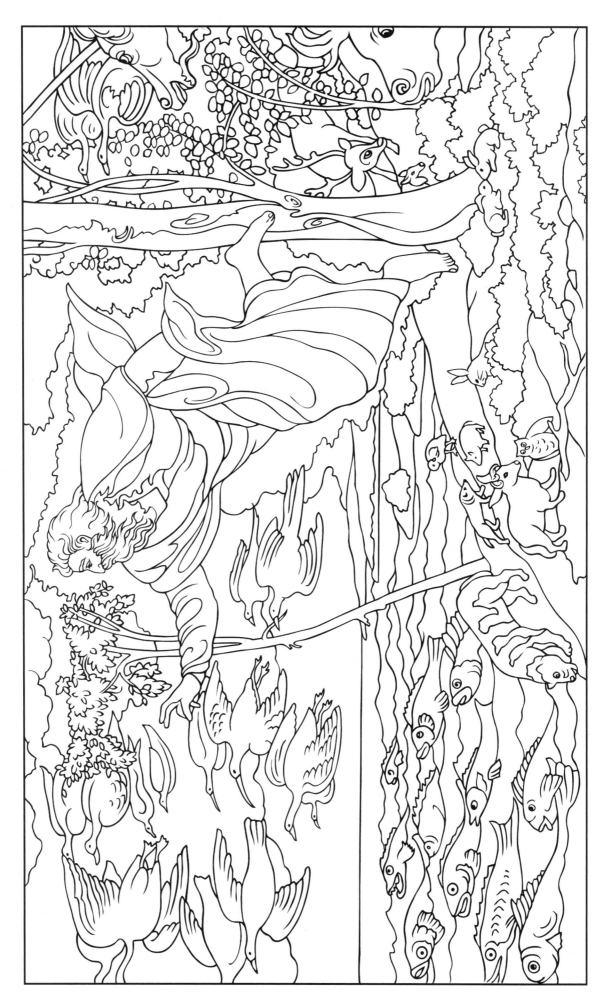

26. **Tintoretto** (Jacopo Robusti; 1518–1594). *Creation of the Animals.*

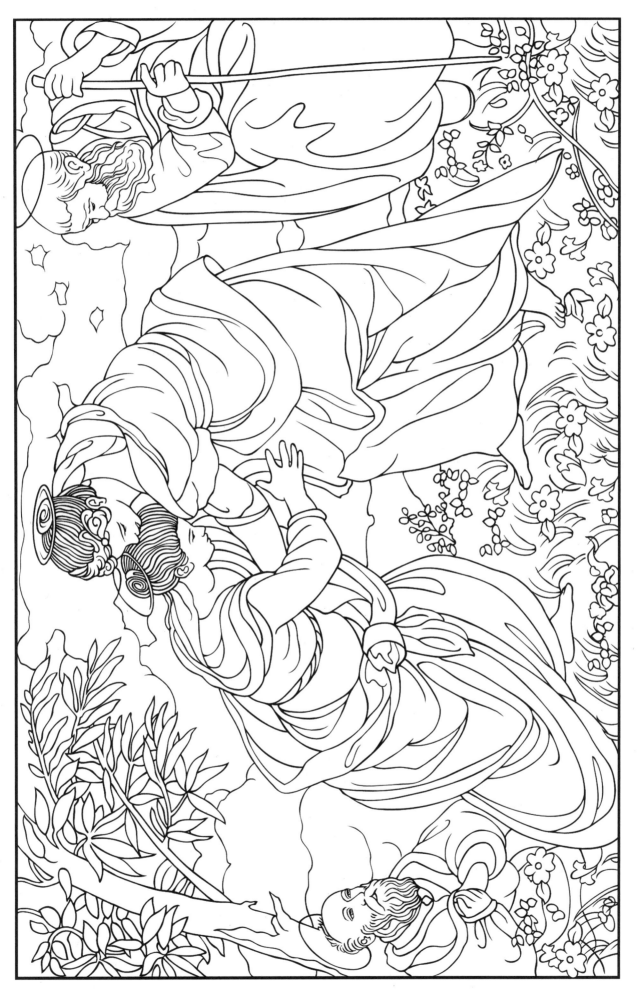

27. **Tintoretto** (Jacopo Robusti; 1518–1594). *The Visitation.*

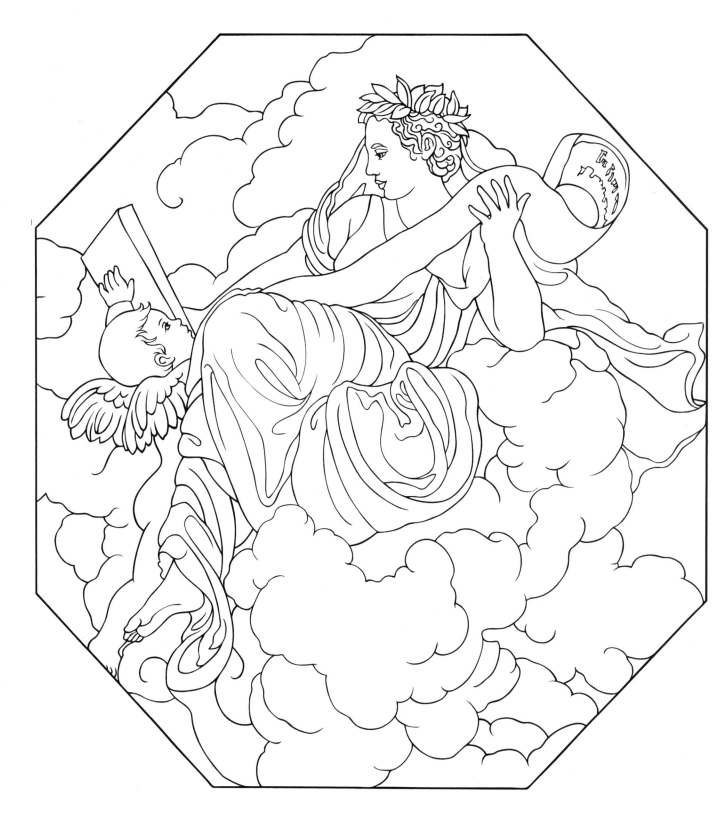

28. **Titian** (Tiziano Vecellio; 1477/90–1576). *Wisdom.*

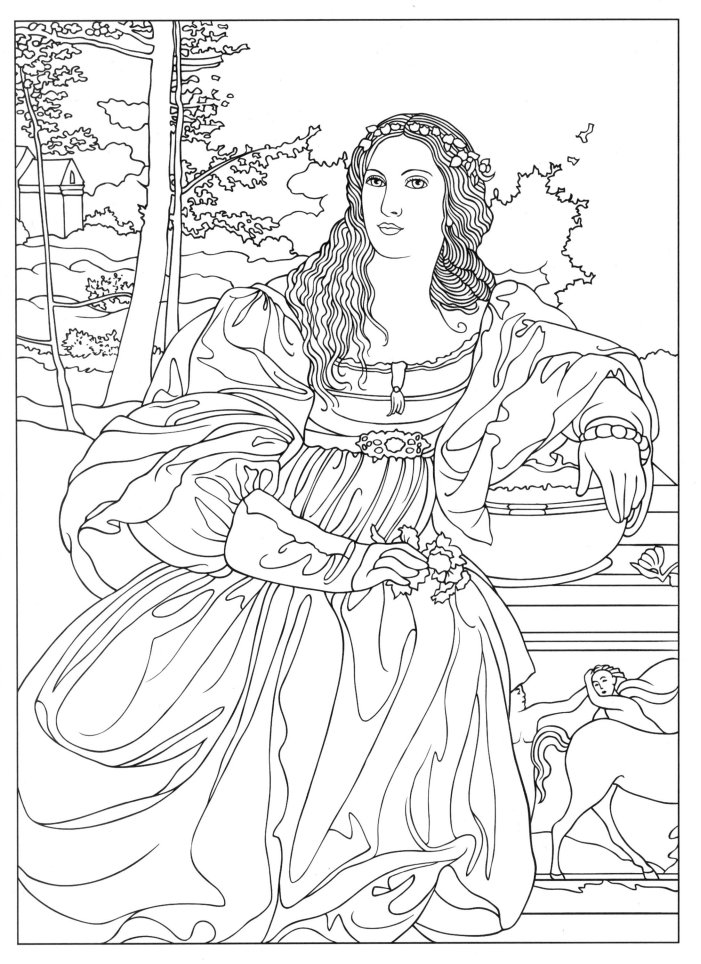

29. **Titian** (Tiziano Vecellio; 1477/90–1576). *Sacred and Profane Love* (detail).

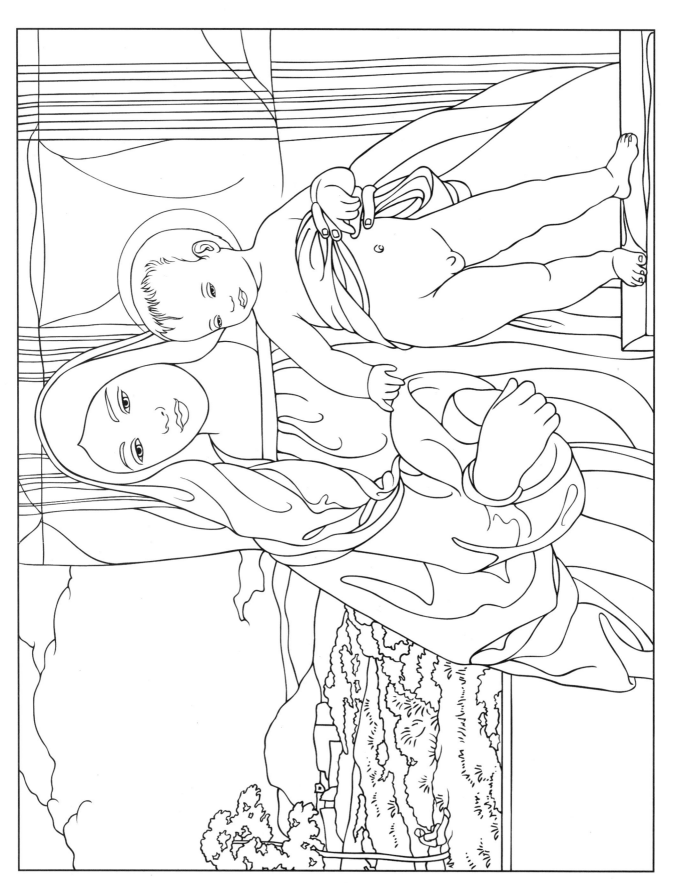

30. **Titian** (Tiziano Vecellio; 1477/90–1576). *Gypsy Madonna.*